PRICE: $6.99 (3594/02)

Michelangelo
His Life and Art

Charles G. Quill

The Rosen Publishing Group's
READING ROOM
Collection™

New York

Published in 2003 by The Rosen Publishing Group, Inc.
29 East 21st Street, New York, NY 10010

Copyright © 2003 by The Rosen Publishing Group, Inc.

First Library Edition 2003

Book Design: Haley Wilson

Photo Credits: Cover. pp. 1, 4, 8, 11, 14–15 © Art Resource; p. 7 © Corbis-Bettmann; pp. 12, 16 (Full Page) © Scala/Art Resource; p. 16 (lower right) © Erich Lessing/Art Resource; pp. 18–19 © Alinari/Art Resource; pp. 20–21 © Corbis; p. 21 © Corbis.

Library of Congress Cataloging-in-Publication Data

Quill, Charles G., 1971-
 Michelangelo : his life and art / Charles G. Quill.
 p. cm. — (The Rosen Publishing Group's reading room collection)
Summary: Introduces the life of the artist who painted the frescoes on the ceiling of the Sistine Chapel, but whose greatest love was sculpture.
 ISBN 0-8239-3749-6
 1. Michelangelo Buonarroti, 1475-1564—Juvenile literature. 2. Artists—Italy—Biography—Juvenile literature. 3. Art, Renaissance—Italy—Juvenile literature. [1. Michelangelo Buonarroti, 1475-1564. 2. Artists.] I. Title. II. Series.
 N6923.B9 Q55 2002
 709'.2—dc21

 2001007298

Manufactured in the United States of America

For More Information
WebMuseum: Michelangelo
http://www.oir.ucf.edu/wm/paint/auth/michelangelo/

Contents

4

Birth of an Artist

Michelangelo (my-kuhl-AN-juh-loh) is considered one of the greatest artists who ever lived. He was born in a small town in Italy—a country in southern Europe—in 1475. When Michelangelo was young, his family moved to Florence (FLOR-ens), a rich and powerful city in Italy. When he was only twelve, his father sent him to study with the most famous painter in the city.

Many important artists and writers lived in Florence during this period, which is called the **Renaissance** (REHN-uh-sahns). "Renaissance" means "rebirth." The Renaissance started in the early 1300s and lasted until about 1550. During this time, the people of Italy became interested in their past. They wanted to try to copy the great things done by the ancient Greeks and Romans.

Michelangelo was an important part of the Renaissance. Many of the artistic advancements of the Renaissance took place in Italy.

Michelangelo soon became very interested in sculpture (SKULP-chur). Sculpture is the art of carving or creating **statues** from blocks of stone, metal, wood, or clay. Michelangelo decided he wanted to make sculptures like those the ancient Greeks and Romans made. He left his painting teacher and went to a sculpting teacher to learn the art of sculpting.

Michelangelo made his sculptures out of marble, which is a very hard stone. He used a hammer and a **chisel** to chop away small pieces of marble and shape his figures. Michelangelo often said that the statues he carved were trapped inside the blocks of stone. He said his job was to free them by cutting away the stone around them.

Michelangelo was inspired by ancient Greek and Roman sculptures, like the example shown here.

The Young Artist

Michelangelo found his first **patron** when he was still a teenager. The ruler of Florence, Lorenzo de Medici (law-REHN-zoh duh MEHD-ih-chee), saw that Michelangelo was very talented. He invited Michelangelo to live in his palace and study ancient **civilization** and art.

In 1496, Michelangelo moved to Rome. Rome was the capital of Italy and was the home of the Catholic church. Michelangelo studied the city's painting, sculpture, and buildings. He found patrons in Rome to support his art. He carved a large statue of an ancient Roman god for one church official. For another, he made one of his most famous sculptures. It shows an important Christian subject. This statue is called the *Pieta* (pee-ay-TAH).

Michelangelo was only twenty-three years old when he carved this famous statue, the *Pieta*.

The style of Michelangelo's *Pieta* was plainer than most other statues of this time, and it showed a great sadness. This had a strong effect on people, and the statue brought Michelangelo fame as a great sculptor.

After several years in Rome, Michelangelo returned to Florence in 1501. Three years later, he created one of his most famous statues, called *David*. The statue shows how ancient Greek and Roman art influenced Michelangelo. The statue of *David* is over fourteen feet tall and was carved out of a single piece of marble. It shows Michelangelo's great understanding of the human body. Many people consider *David* to be Michelangelo's greatest work.

Michelangelo's *David* is one of the most famous statues in art history. Even today, thousands of people go to see the statue every day.

The Sistine Chapel

Michelangelo thought sculpture was the highest form of art. He never thought of himself as a painter. Yet one of Michelangelo's greatest works was painting the ceiling of the Sistine (SIHS-teen) **Chapel** in Rome.

In 1505, **Pope** Julius II had asked Michelangelo to come to Rome to build a **tomb** for him that would include many statues. Michelangelo began work on the tomb, but the project was stopped in 1506 because a war had started in Italy.

Since Michelangelo was not working on the tomb, Julius II asked him to paint the ceiling of the Sistine Chapel in 1508. Michelangelo accepted. He created a series of **frescoes** across the ceiling of the chapel that show scenes from the Bible. Michelangelo spent four years high above the chapel's floor to finish it.

Michelangelo painted over 400 figures on the ceiling of the Sistine Chapel in Rome.

Working on the Sistine Chapel ceiling affected Michelangelo's body and mind. He had to lie on his back on a special platform just beneath the ceiling every day for four years to finish his work. Having to spend so much time painting made Michelangelo unhappy. He did not like to paint. He believed that God had given him a talent that was meant to be used to make sculptures. The years he spent alone on the job added to his sadness.

The Creation of Adam is one of the most famous images from Michelangelo's Sistine Chapel painting. It shows God creating man.

When Michelangelo had finished the job, he had created some of the finest paintings anyone had ever seen. His work on the Sistine Chapel ceiling set a new standard for painting. Artists from all over the world came to Rome to see what he had done. More than twenty years later, he returned to the chapel to paint one more fresco, which took him five years to finish.

The Sculptor as Architect

When the Sistine Chapel ceiling was completed, Michelangelo began drawing the plans for the tomb of Pope Julius II and deciding what statues the tomb would hold. He also began sculpting again, carving the statues for the tomb. Michelangelo did not finish all the work included in the original plan, which called for about forty statues. By 1516, he had produced some of his finest sculpture, including *Moses* and the *Bound Slave*. The statue of *Moses* was used as a centerpiece for the tomb.

Many statues that had been planned for Julius II's tomb were left unfinished. Michelangelo often left pieces unfinished, either because he did not like them or because he did not plan to use them.

The tomb of Pope Julius II includes some of Michelangelo's best work, including *Moses*, the statue seen here.

Around this time, Michelangelo began to work as an **architect** (AR-kih-tekt) **designing** buildings. He returned to Florence in 1519 and began drawing plans for a library for the Medici family's book collection. Michelangelo also began work on the Medici tombs, which included more of his sculptures. The tombs were never finished and are now in a chapel that Michelangelo also designed.

In 1534, Michelangelo returned to Rome. A few years later, he began planning a city square in Rome. Michelangelo also designed some of the government buildings that were built around the square.

Michelangelo designed this city square and the oval at its center to show Rome as the center of the world.

In 1546, Michelangelo began designing the **dome** of St. Peter's in Rome. St. Peter's is one of the largest churches in the world. It is also one of Michelangelo's most famous building designs. The top of the dome rises 435 feet above St. Peter's Square. Many domes around the world are modeled after it, including the dome of the U.S. Capitol in Washington, D.C.

Construction on St. Peter's started in 1506 and took about 150 years to finish. Michelangelo was one of ten different architects who worked on the building.

Michelangelo was never paid for his work on St. Peter's. He died before the church's dome was ever finished.

United States Capitol

His Final Years

During the last years of his life, Michelangelo did less sculpting than he had done as a younger man. He finished sculpting jobs for patrons and worked on two more pietas that he did not finish. One of these pietas is called the *Florentine* (FLOR-en-teen) *Pieta*. The *Florentine Pieta* was meant to be a part of Michelangelo's own tomb. In this statue, Michelangelo appears as the old, hooded man helping to hold up Christ's body.

Michelangelo died in 1564 at the age of 89. Today, people from all over the world visit **museums** and churches to see his beautiful works of art.

Glossary

architect Someone who plans how buildings are built.

chapel A building for religious services that is smaller than a church.

chisel A metal tool with a sharp edge used to cut and shape stone, wood, or metal.

civilization A way of life followed by the people of a certain time and place.

design To draw plans for something, like a building.

dome A roof shaped like half of a ball, usually found on a church or other large building.

fresco A painting done on wet plaster on a wall or ceiling.

museum A place where people can go to see art.

patron Someone who helps support an artist, usually with money.

pieta A painting, drawing, or statue showing Mary with the body of the dead Christ on her lap.

pope The head of the Catholic church.

Renaissance The fourteenth, fifteenth, and sixteenth centuries in Europe, when artists copied the style of ancient Greek and Roman art.

statue A figure made from stone, wood, metal, or clay.

tomb A building for burying people above ground.

Index